North American Indian Crafts

Peter F. Copeland

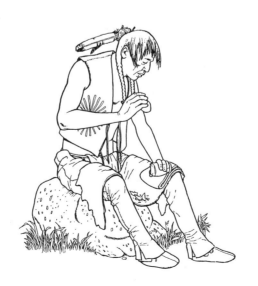

Dover Publications, Inc.
Mineola, New York

Bibliographical Note

North American Indian Crafts is a new work, first published by Dover Publications, Inc., in 1996.

DOVER *Pictorial Archive* SERIES

International Standard Book Number: 0-486-29283-5

Manufactured in the United States of America
Dover Publications, Inc., 31 East 2nd Street, Mineola, N.Y. 11501

Note

THE ARTS AND CRAFTS developed and practiced by the Indian peoples of North America varied as much from one geographic area to another as did the people themselves and their way of life. The substances they worked and the tools they used were either native to the particular region or else obtained through trade. Many of these substances came from the animal kingdom: seashells, feathers, animal horn, bone, porcupine quills. Others came from the earth, such as jade, obsidian, flint and other stones. Wood was widely used as building material and in fashioning vessels. Roots, twigs, earth, grass, clay, berries and vegetables provided dyes. Pottery and basketry were highly developed into unique styles and shapes.

Each tribe, from the most sophisticated to the least progressive, sought to develop a craft technology to suit its own needs, using available materials.

After European contact, unfamiliar diseases, warfare, invasion and displacement decimated huge numbers of Native Americans. Whole tribes became virtually extinct and many ancient and unique tribal crafts died with them, some to be lost forever.

Seen in this book are some of the various crafts practiced by the Native American peoples of North America and of the Inuit people of the Canadian and Alaskan Arctic regions.

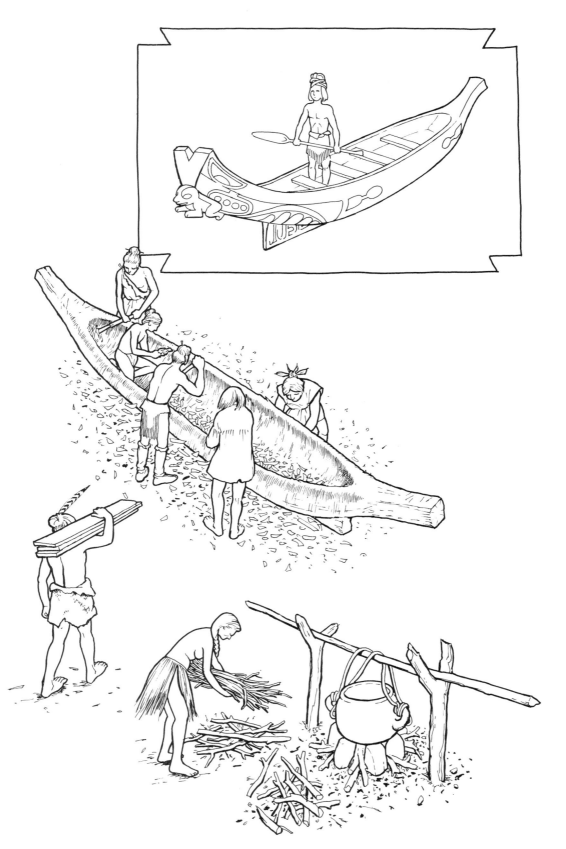

Northwest Coast Indians building a dugout canoe.
This huge canoe was made from a single tree. A giant log was hollowed out and shaped using adzes and chisels. The hollowed-out area was then filled with hot water, which softened the wood so that the builders could drive wedges and cross pieces (seats) into the sides. The finished canoe was then carved and painted with ceremonial designs. Members of the Lewis and Clark expedition first observed such canoes in 1805 near the mouth of the Columbia River.

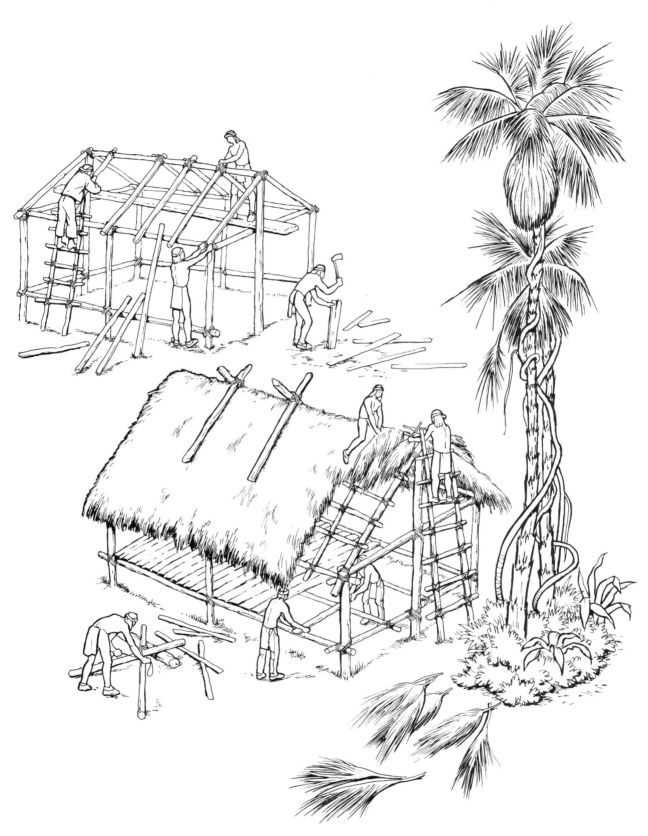

Building a Seminole palmetto house ("chickee"). The warm climate of Florida and the Gulf coast, the home of the Seminole people, made house walls unnecessary. The frame was constructed of palmetto logs lashed together with strips of wet hide. The roof was covered with bundles of palmetto leaves fastened together and held in place by log beams laid over the matting. The floor was a raised platform covered with split palmetto logs.

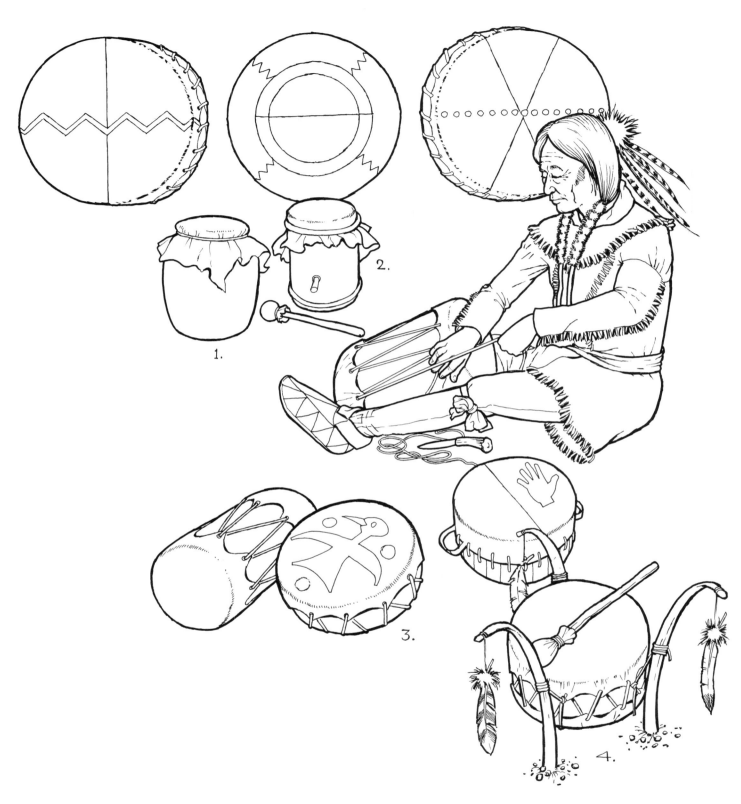

Making drums. Native Americans took great pleasure in music. Every tribe had songs and music for religious ceremonies, games, dances and prayers. In this picture, a drum maker is tightening the rawhide lacing on a double-headed cylindrical Pueblo-style drum, the heads of which are made of sheepskin or calfskin. Figure 1 is essentially a clay pot. Figure 2 is a water drum, its tone regulated by the amount of water inside it. Figure 3 exemplifies three different kinds of drum construction. Figure 4, a ceremonial drum, is suspended from stakes. At the top are different styles of decoration.

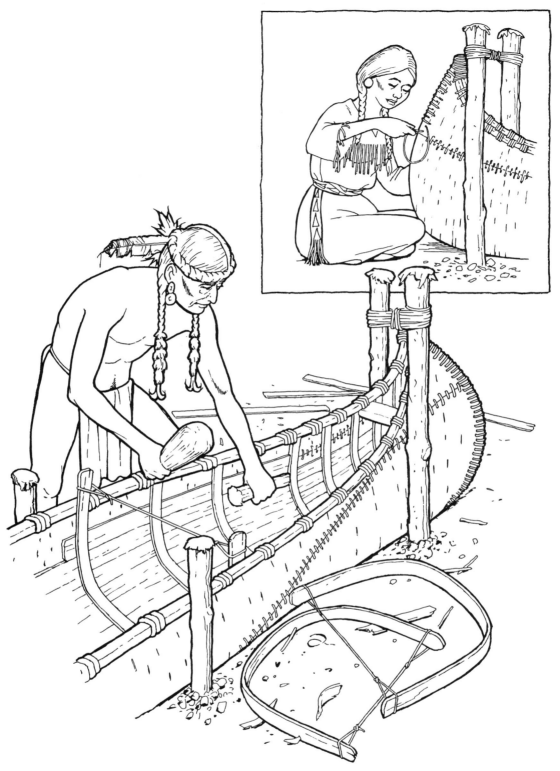

Building a bark canoe. The bark canoe was built by Indian tribes all over the northeastern part of North America as far west as the Great Lakes. It would take 10 to 20 days for two men and four women to finish a new canoe. In assembling the necessary material, the women dug and prepared spruce and tamarack root for sewing seams and gum for caulking. Birch trees provided the large sheets of bark needed for the skin of the canoe. The inner frames, or ribs, were of molded wood planking, held in shape by rawhide thongs. The canoe was held together with glue and root-thread stitching. The interior of the canoe was sheathed with thin wood planking. Thwarts, or seats, were fitted in and lashed to the rails, and an outside gunwale was put on over the lashings. There were variations in design and construction methods from one tribe to another, but they were all much alike. The Chippewa canoes of the western Great Lakes were particularly handsome.

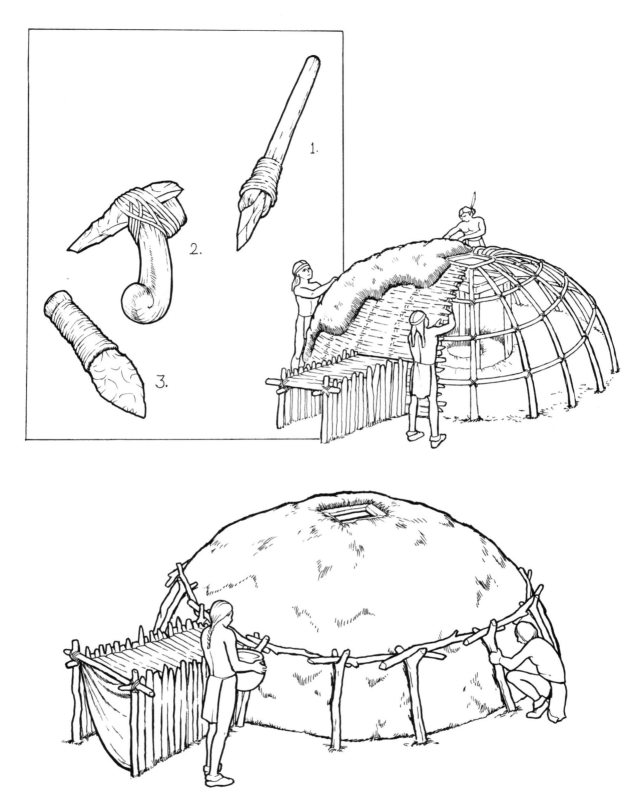

Building a Mandan lodge. The midwestern plains Mandans were migratory during the hunting season, living in teepee villages and following the great buffalo herds, which provided them with many of their needs. In the winter, however, the Mandans constructed large wooden lodges and settled in them for the season. Made of wooden posts covered with bundles of branches and grasses, over which mud and sod were plastered, the typical lodge was about 10 feet high and 30 feet in diameter and held up to 100 people. The inset drawing portrays the types of tools used by the Mandans before the arrival of the Europeans: (1) a nephrite chisel; (2) a flint hand adz; (3) a flint knife with wrapped wooden handle.

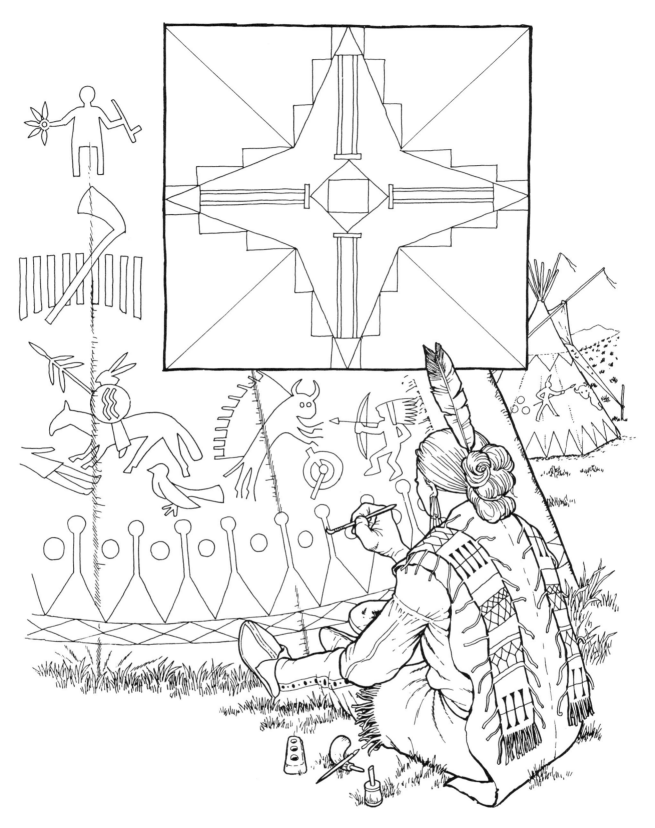

Painting history on teepee coverings. Over 20 buffalo hides were needed to make a Plains Indian teepee covering. The hides were sewn together in a conical shape and attached to a wood frame. The teepee covering was often painted with geometric designs and pictographic illustrations of tribal history, wars and hunting achievements. Sometimes, cosmic events were painted, such as the meteorite shower that occurred in 1834. Symbols were often used in the painting to create a sort of pictorial shorthand. The inset drawing shows a geometric design painted on the hide-and-frame door of a teepee.

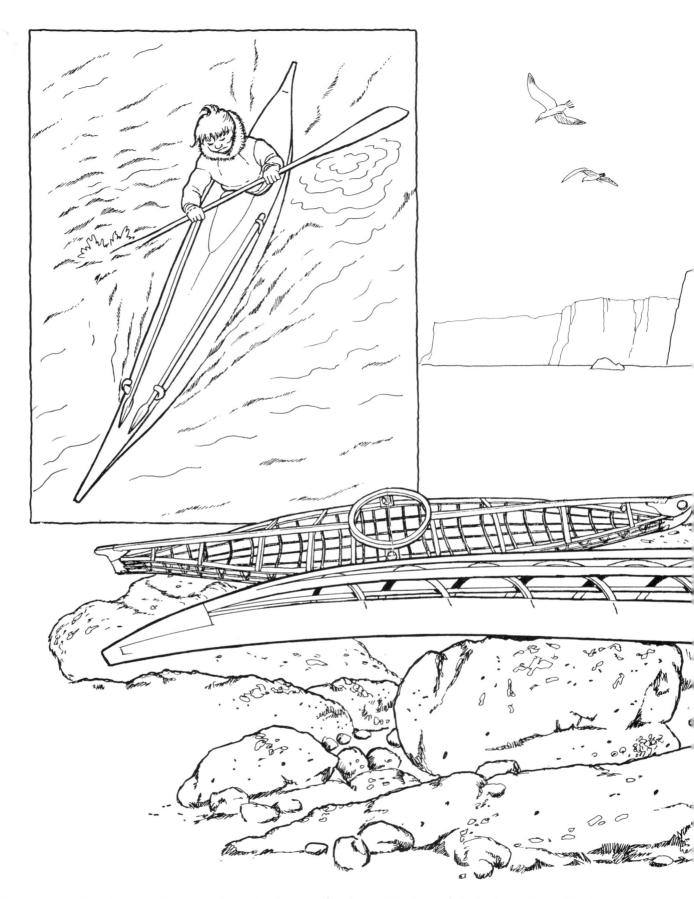

Building an Inuit kayak. A kayak, which is made of a light wooden frame covered with caribou or seal skin, weighs between 25 and 100 pounds and can be 15 to 25 feet long. The frame is lashed together with sinew and the skin is treated with animal oil to keep it tight and waterproof. In the inset frame, an Inuit hunter

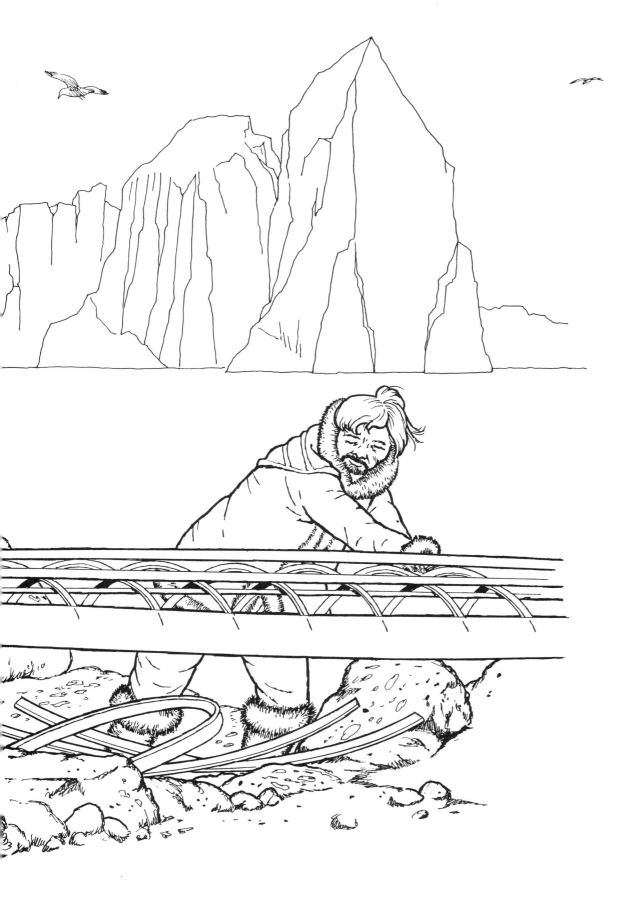

maneuvers his kayak along a lake shore near Hudson Bay. He has laid his caribou lances along the sides of the kayak, ready for use. The hooded jacket and the snug fit of the cockpit coaming will keep the hunter dry even in heavy seas.

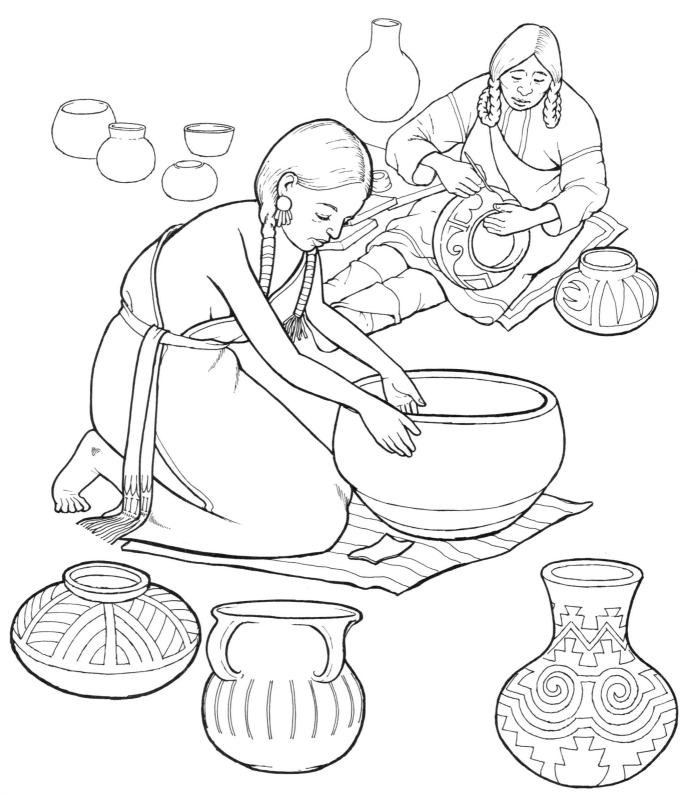

Making and painting ceramic pots. Native Americans have long been famous for their pottery skills. Once the materials and paints were assembled, a skilled potter could make half a dozen pots in a day—more if they were small. Once they were done, the pots were put aside until the next day, when they were baked. Native American potters did not use a potter's wheel. Most eastern pottery was made by working a lump of clay into the desired shape, then cutting decorative patterns into the surface. In the Southwest, potters rolled wet clay into long snakes, then coiled it around in layers and smoothed it out by hand. The pots were carefully polished and painted over with intricate designs, such as those in the lower left of the drawing.

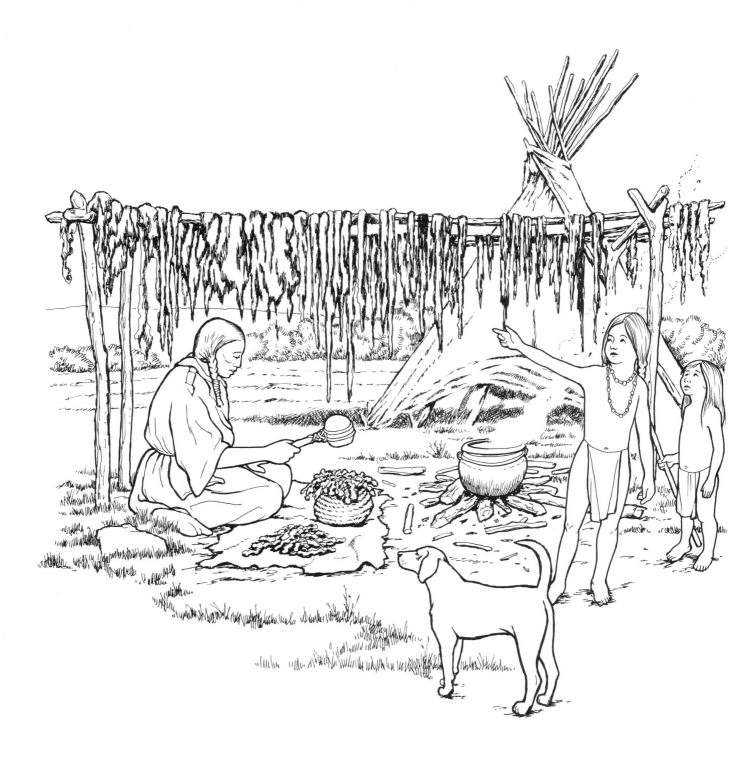

Making pemmican. An important food in the winter diet of the Plains Indians was pemmican. Made from dried buffalo meat pounded with dried berries and mixed with melted marrow fat, pemmican was packed in rawhide bags where it would keep indefinitely until needed. Plains Indians relied heavily on pemmican during their long migratory journeys following the buffalo herds.

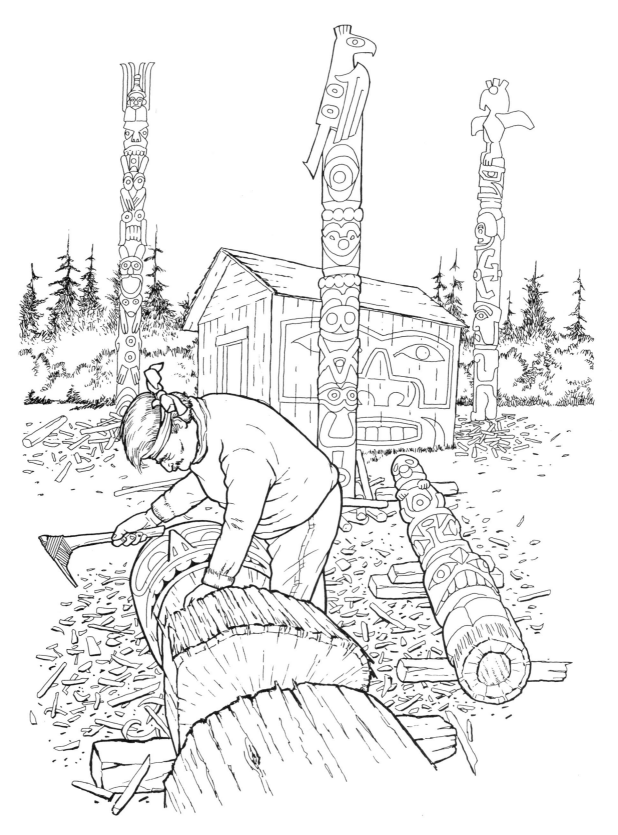

Carving totem poles. The Pacific coastal tribes of the Northwest lived in great wooden houses which were often lavishly decorated with fantastic paintings and carvings representing characters in tribal myths. Outside the house, a carved and painted pole was erected bearing the crests, or totems, of the family and symbols from tales of family history. These totem poles were sometimes 50 feet tall. Here we see a carver at work and several of his creations in various stages of completion. In ancient times, Indians used stone tools to fell and carve the huge cedar trees of the Northwest forests.

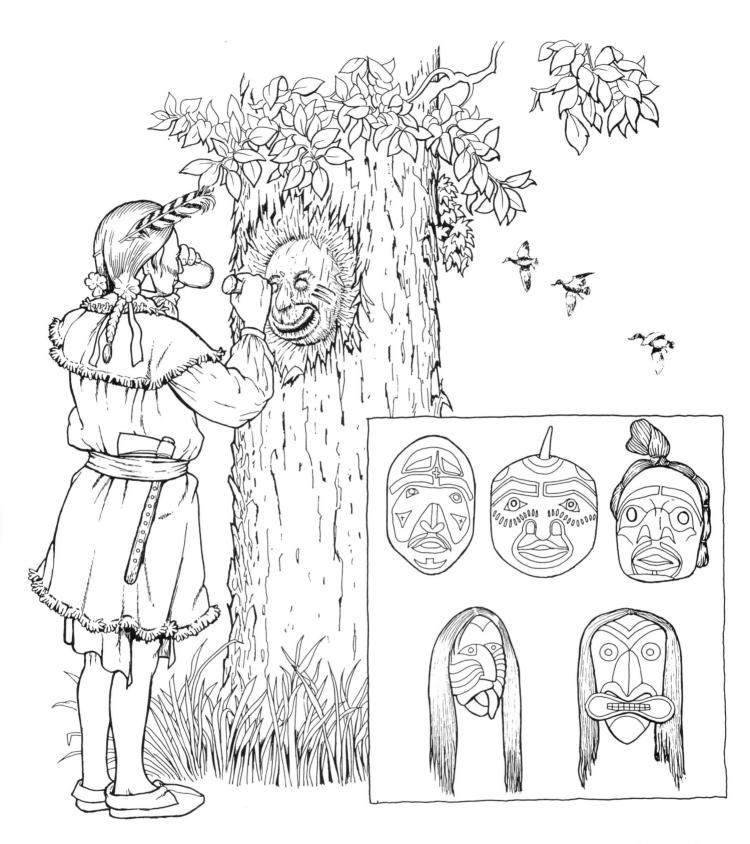

Making masks. Masks were largely ceremonial or religious in nature. Many dances required masked dancers, especially among the tribes of the Southwest. The Iroquois of the eastern woodlands carved elaborate masks into the trunks of living trees (seen at the left above). These masks, ugly or deformed human faces, were for members of the False Face Society, to protect the people from evil spirits. At the top of the inset drawing are three Northwest Coast wooden masks; at the bottom, two Iroquois masks.

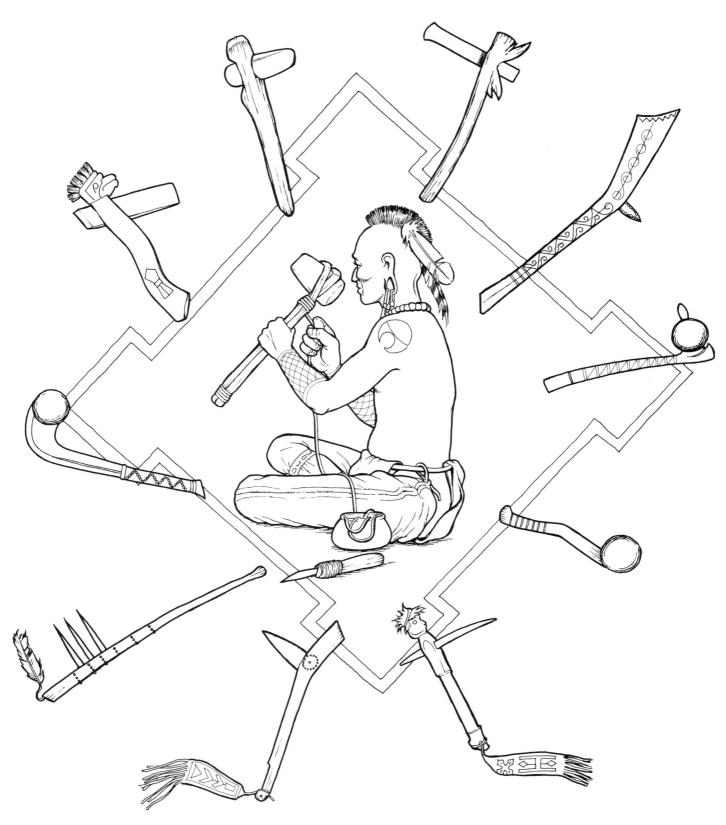

Making tomahawks. There were several major types of tomahawks. Early models consisted of a wooden shaft with a polished, ball-shaped head that sometimes had a spike or sharp tooth laid into it. Later, stone heads were tied to the shaft, and eventually the stone was sharpened. When the Europeans came, they introduced the durable, sharp iron-headed hatchet and began mass-producing the modern version of the tomahawk to trade with the Indians. Tomahawks were used as tools as well as weapons. Above, we see a craftsman and a variety of pre-Contact tomahawks.

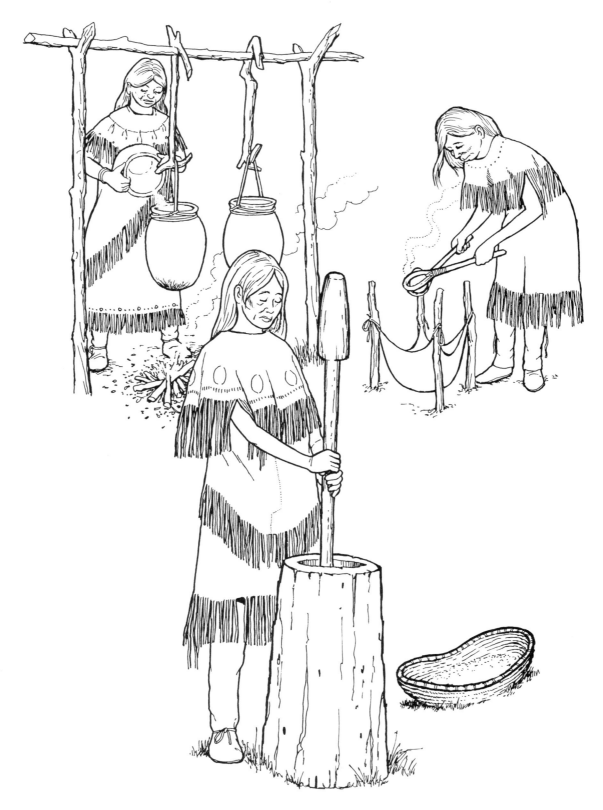

Preparing food. Corn was one of the major crops of the Native Americans, and it was turned into a variety of foods, such as succotash, hominy, parched corn, corn cakes and corn bread. After the harvest, corn was ground into meal by means of a wooden mortar and a double-ended pestle. The corn was then sifted and cooked in either an earthenware pot (above left) or by the hot stone method in a paunch pot made from the stomach of a buffalo. The paunch was filled with water into which hot stones were dropped until it boiled, after which the cornmeal was added. In addition to corn, the Indians harvested squash, wild rice, acorns, various roots, pumpkins, potatoes and fruit. Wild game was a major food source as well.

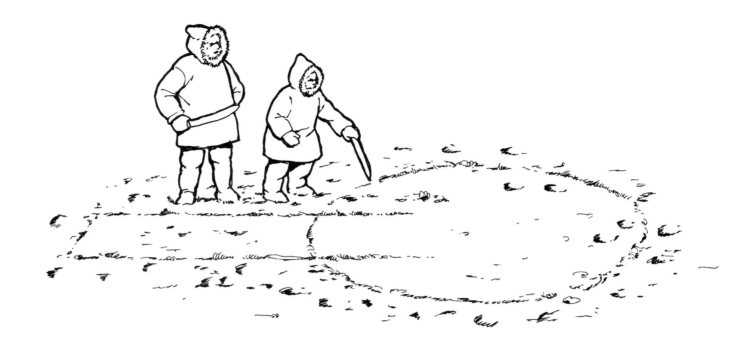

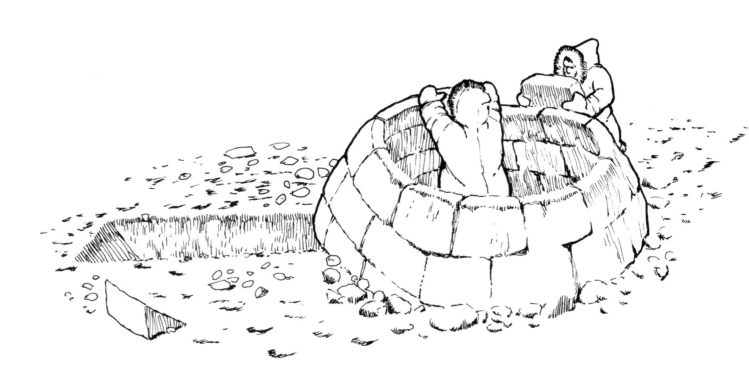

Building an igloo. The most efficient dwelling built by the Inuit in subarctic Canada was the vaulted snow house, or igloo. An igloo could be large or small, and some were large enough to hold a dance party in. The igloo was warm, and it enabled the Inuit to survive in relative comfort through the long northern winters. Two men could build a small, temporary igloo in several hours. The various steps are shown above. First

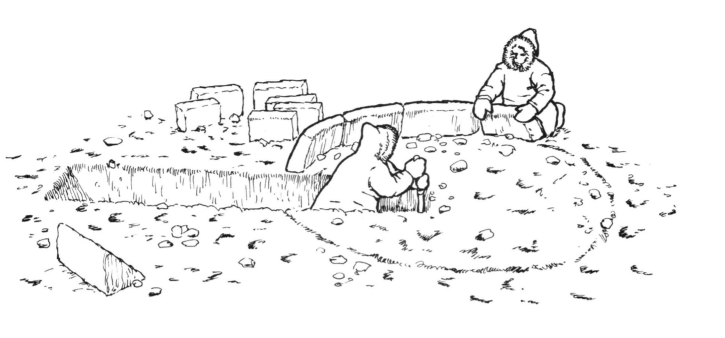

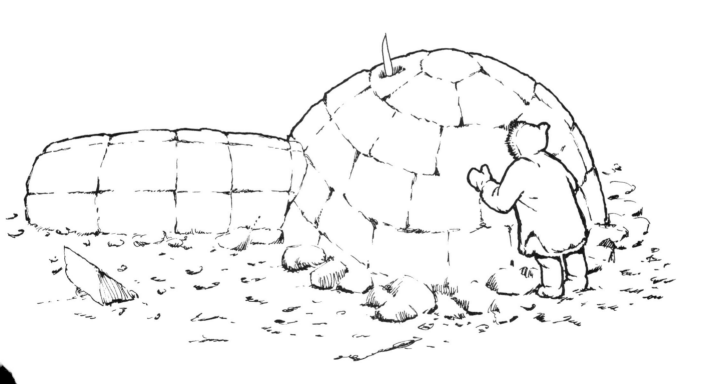

a circle is marked in the snow, and an entrance dug. Using a snow knife to cut blocks of ice and snow at varying angles, the builders pile up the blocks to form the walls of the igloo. When it is done, a small hole is cut in the top to let the smoke out, and the passageway is covered over.

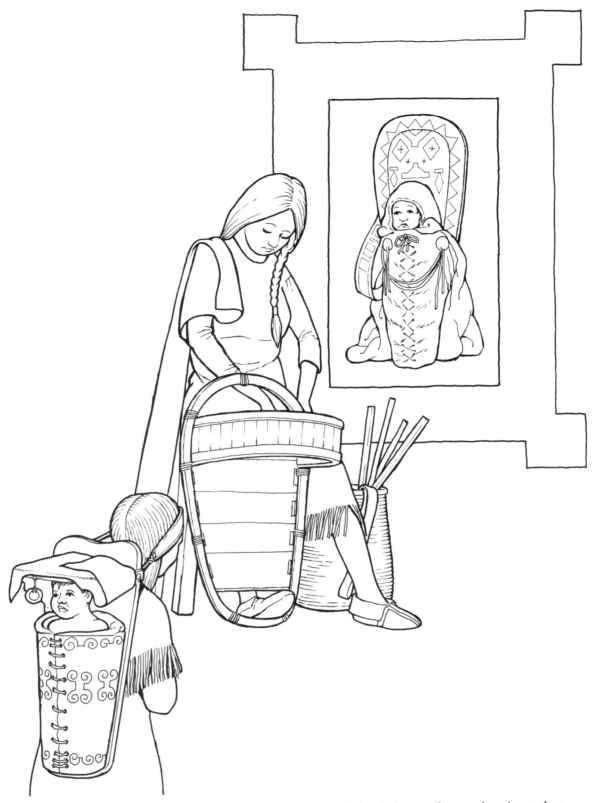

Making cradleboards. Babies were commonly carried on cradleboards. The baby was secured to the cradleboard a few days after birth and kept there until it was ready to walk. A cushion of soft moss and the down from cattails kept the baby comfortable and served as an absorbent diaper. Most cradleboards were made of wood and hide. A small shelf at the bottom supported the infant's feet, and a wooden rim at the top supported a drapery that protected the baby's head from the sun. A leather strap was used to hang the cradle on a peg or as a carrying strap. The cradleboard at top right is from the Nez Percé tribe and the one at the lower left is typical of Algonquians.

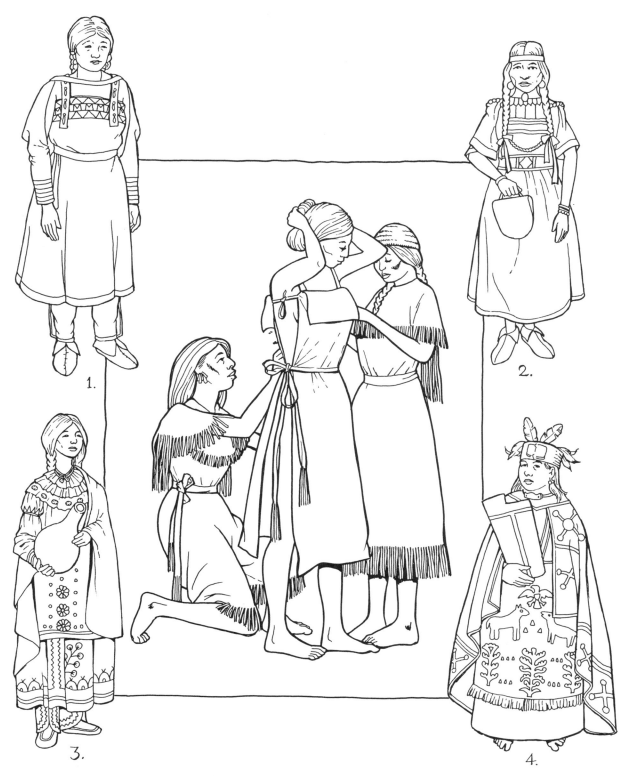

1.

2.

3.

4.

Making clothes. Indians wore practical clothing that was suited to the climate of their region. Before the coming of the Europeans, almost all the clothes were made of leather. Properly tanned buckskin was soft, pliable and extremely durable. Hides from smaller animals were also suitable, but required more skins per piece of clothing. In general, bear and buffalo skin was too heavy for clothing, with the exception of winter robes and blankets. Some ancient Native American tribes were able to produce textiles from reeds, grasses, cedar roots and the inner bark of trees. Twining, plaiting, knitting, crocheting and weaving were all skills used to produce textiles. The typical woman's costume consisted of a gown, a belt, moccasins and leggings. Seen here are nineteenth-century women's clothes of (1) the plains Ojibwa, (2) Nez Percé, (3) Iroquois, (4) Kwakiutl.

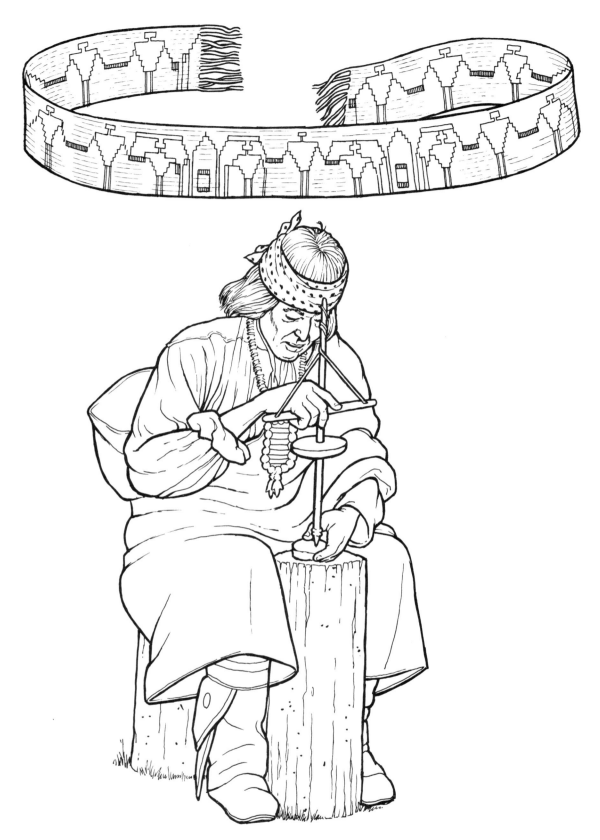

Operating a drill, making wampum. Beaded belts, called wampum, are an ancient tradition among Native Americans. Wampum was used for monetary and ceremonial purposes and came in two colors, purple and white, purple being more valuable. To make wampum, Indians would use a bone drill (such as the Southwestern pump drill seen above) to pierce beads cut out of seashells. The beads were then woven into belts, some over six feet long. After their arrival, the Dutch set up factories to manufacture wampum belts to trade with the Indians for furs.

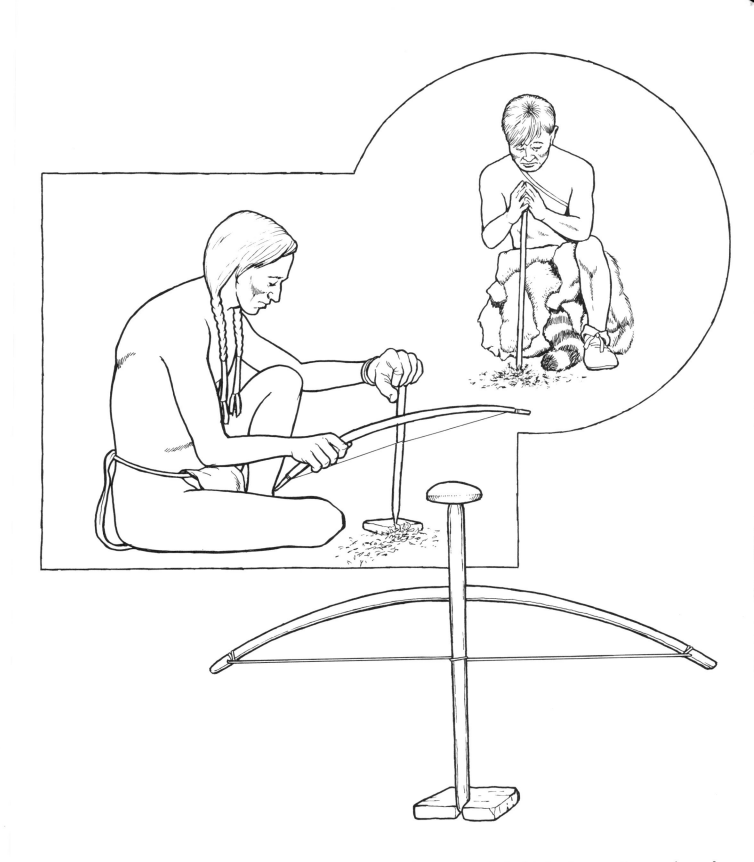

Starting a fire. When it was necessary to start a new fire, the Indians used a drill and a fire board. Sometimes they worked the drill by hand (top), and later they used a bow drill (left and bottom), which was more efficient. The fire board had a notch into which the drill fit. When the drill was rotated, the friction between the two pieces of wood created enough heat to light a small pile of straw or leaves. In sedentary communities, there was often a main fire or bed of coals that was kept burning for years on end.

23

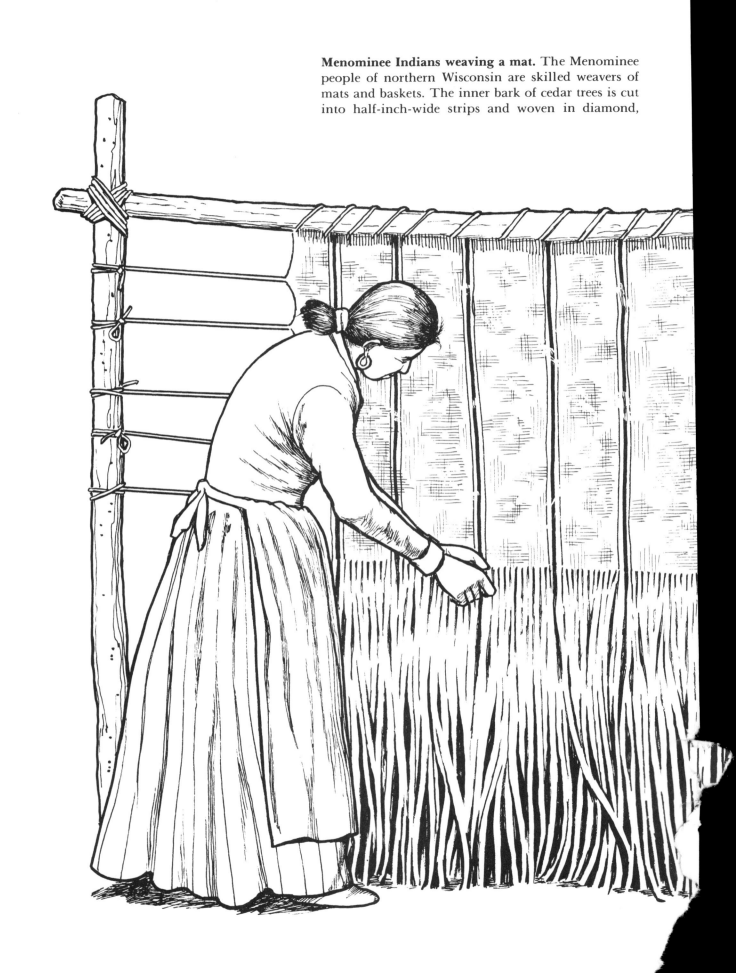

Menominee Indians weaving a mat. The Menominee people of northern Wisconsin are skilled weavers of mats and baskets. The inner bark of cedar trees is cut into half-inch-wide strips and woven in diamond,

zigzag and crosshatch patterns. Some of the mats are nearly white, while others are colored dark red or black using vegetable dyes.

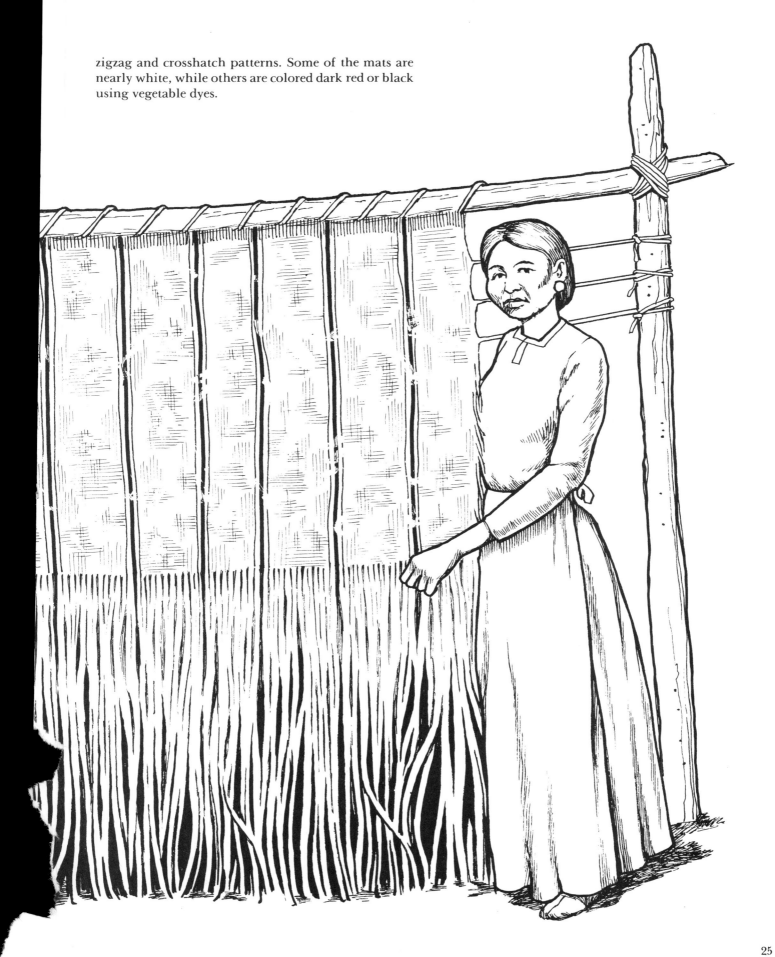

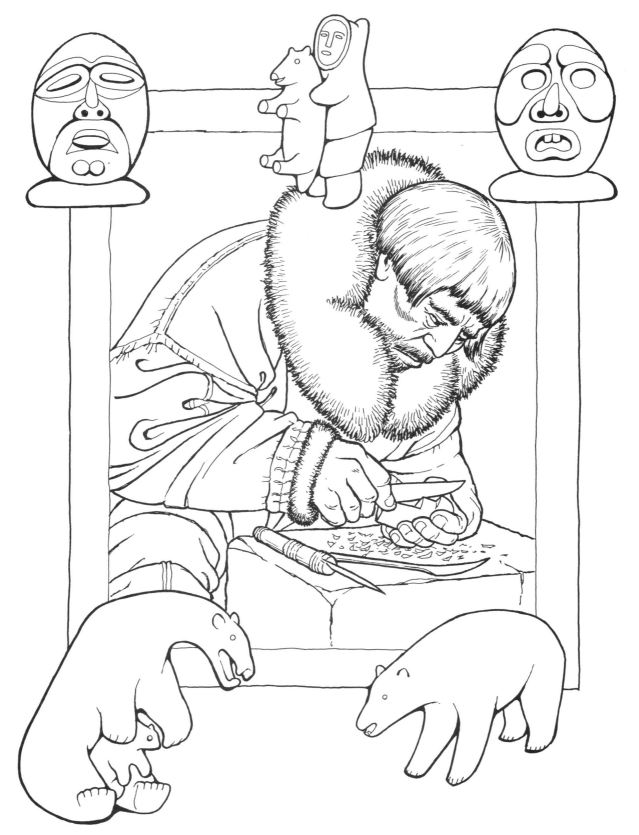

Inuit bone and ivory carving. The Inuit have a long history of carving decorative items. The long Arctic winters provided them with time to pursue various art forms and carving techniques. Forms such as birds, fish and animals were gracefully carved out of bone and ivory. Modern Inuit have found that they can use their skills in carving to bring in money from white traders and tourists. The Inuit now work in whalebone, soapstone, narwhal tusk and wood.

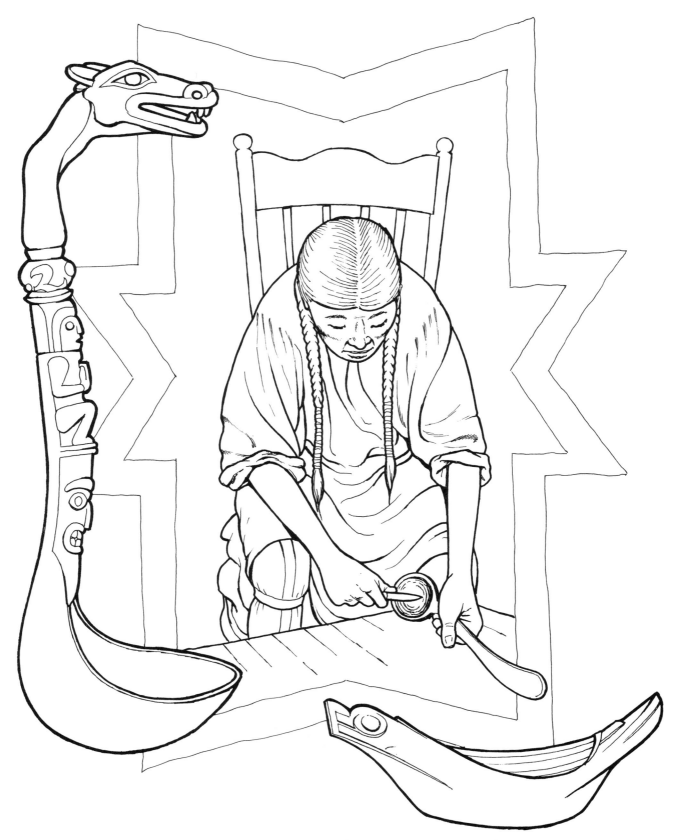

Horn work. The Tlinglit and Haida peoples of the Northwest Coast in Canada produced elaborately carved dishes, spoons, ladles and cups, sometimes inlaid with abalone shells and copper. At the left is a Tlinglit ladle with a carved handle, the top of which represents the head of a wolf. At the bottom is a carved horn dish. The horn of the mountain sheep was soaked in hot water until it was soft enough to be molded into dishes or artwork. Thin slices of horn were glued together and used to strengthen wooden hunting bows.

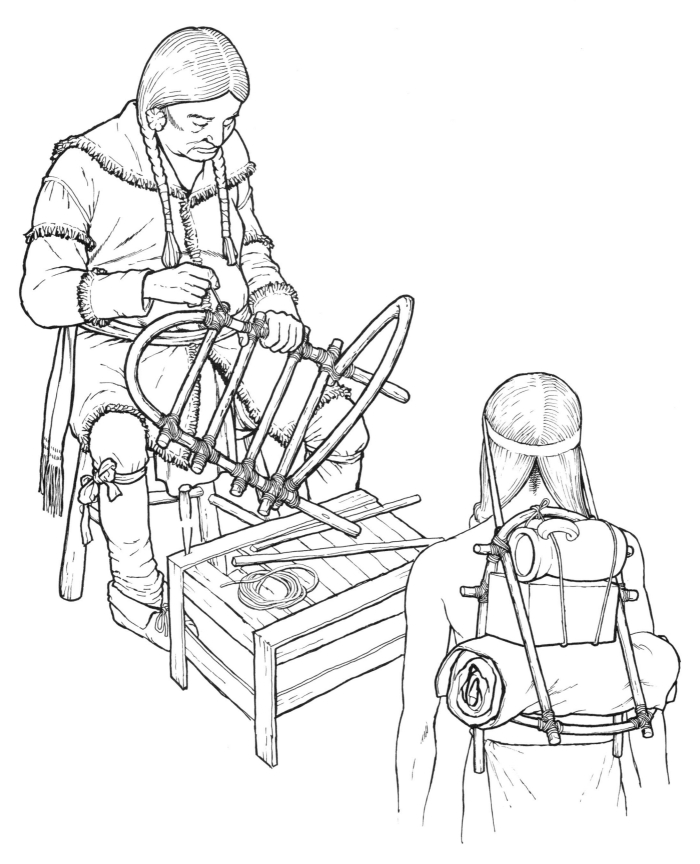

Making a packing frame. The wooden packing frame rested on the carrier's back like a cradleboard. It had a shelf at the bottom to support the load (shown at the right). The tumpline fit over the carrier's forehead, while a chest strap fastened the frame and load to the bearer. The frame was lashed together with hickory bark. The packing frame was popular among the Iroquois in the Northeast.

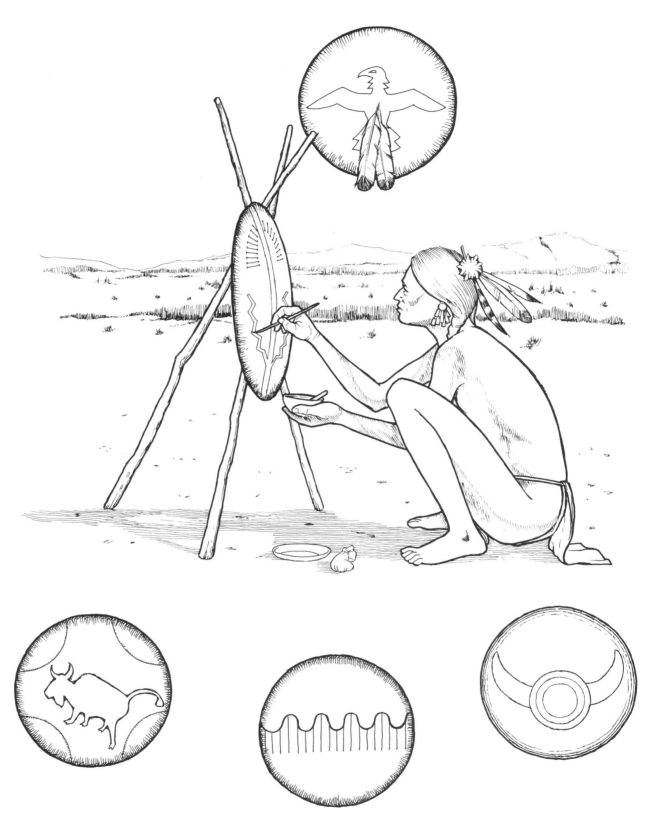

Making a shield. The thick hide on the hump of the buffalo's back provided the material from which Plains Indian shields were made. The circular piece of raw leather was steamed by pegging it over a hole with hot rocks in it. Water was poured into the hole and the resulting steam cured the hide, causing it to shrink and harden. Afterwards, the cured shield was placed over a small mound of dirt so that it would harden into a convex shape. The final step was to paint the shield with individual decorations, some of which are represented above.

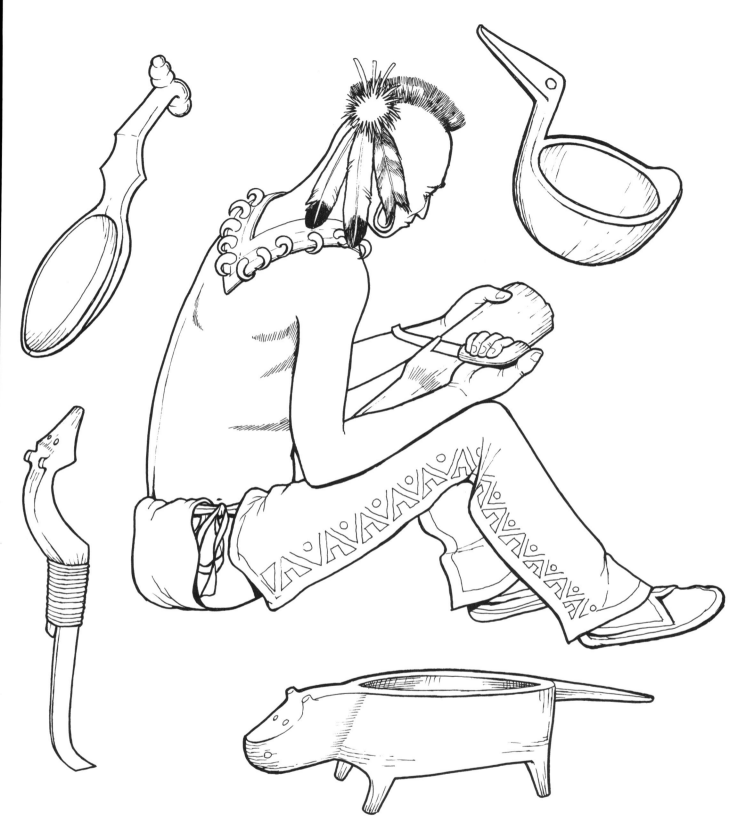

Carving with the crooked knife. The crooked knife, an overhanded draw knife, was very popular among Native Americans. It was designed to cut toward the user rather than away from the user like most modern knives. The blade was often bent at the tip to facilitate gouging. The knife was especially useful for hollowing out wooden bowls and cups. Upper left: Ladle. Upper right: Medicine bow. Lower left: Crooked knife from the Fox tribe. Lower right: Kaskaskian beaver-shaped bowl.

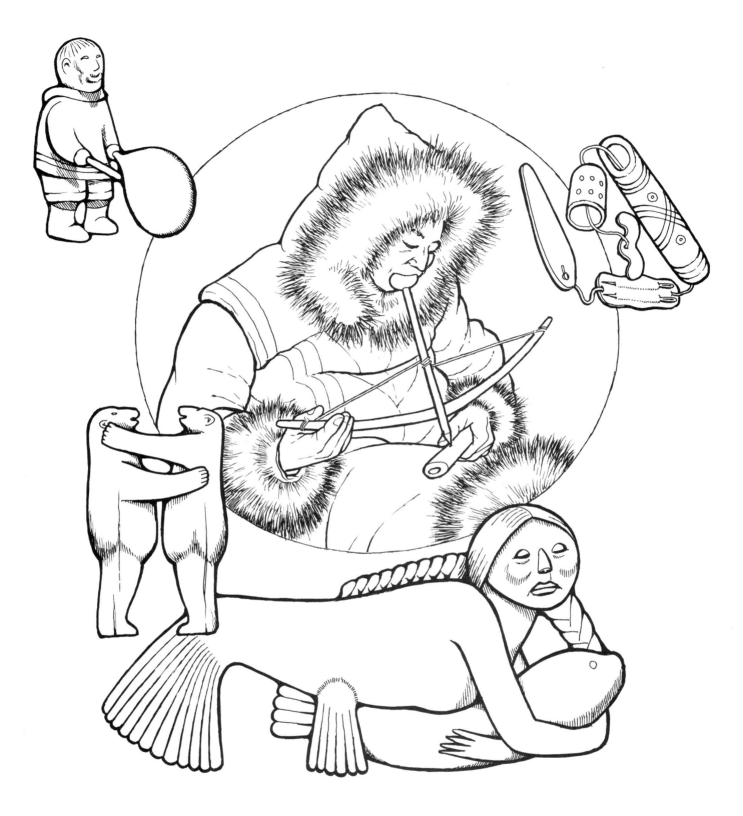

Operating the Inuit bow drill. The bow drill the Inuit used to work bone and horn was a heavy-duty version of the drill the Indians used to make wampum. The upper end of the shaft was fitted with a polished knob that could be gripped with the teeth. The shaft rotated in the knob without having to be held. As a result, the craftsman had two hands to work with: one to draw the bow back and forth, and one to hold the object, in this case a piece of bone. The illustration shows some of the types of carvings the Inuit made, including a goddess riding on the back of a seal (bottom).

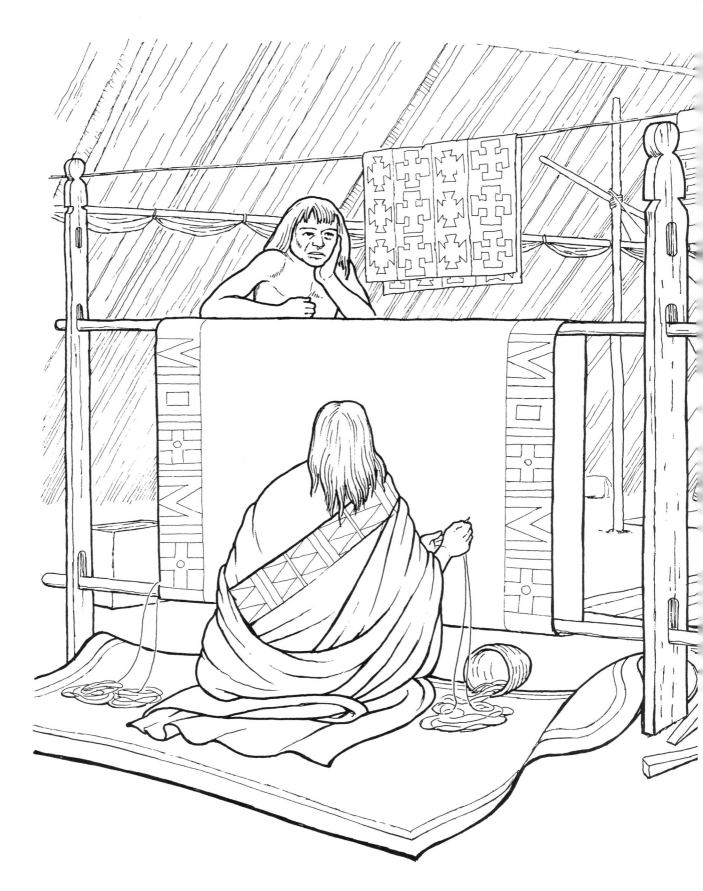

Weaving blankets and rugs. The Chinooks, from the Columbia river area, and the Salish, from the coast of British Columbia, were some of the finest weavers of their time. Their robes and blankets, woven from plant fibers, mountain-goat wool and the fur of a dog that is now extinct, were highly valued and heavily traded

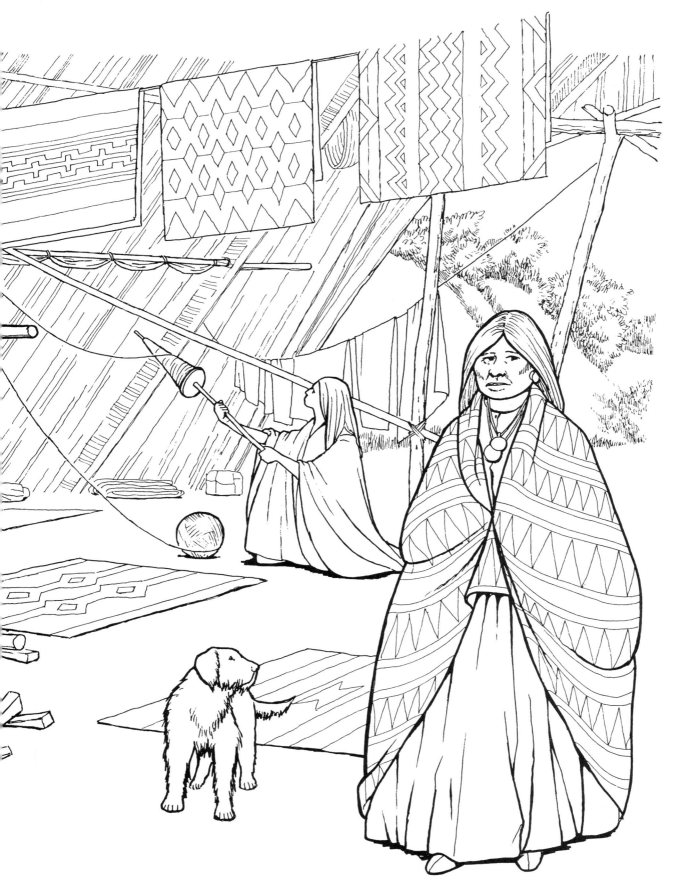

among the tribes of the northern Pacific coast. This illustration shows Navajo blankets hanging on a line. The Navajo, who live in the Southwest, made blankets out of sheep's wool and dyed them with bright reds, yellows, whites and blues.

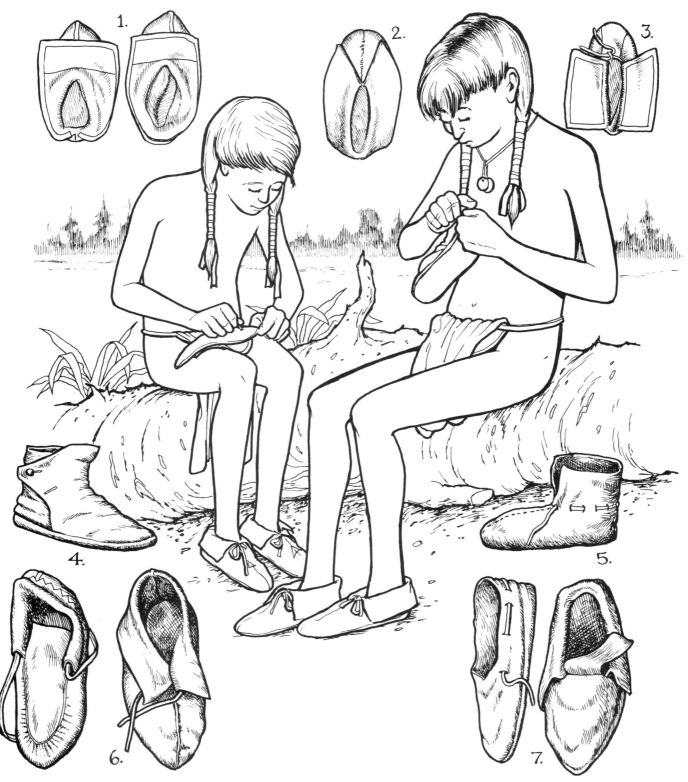

Making moccasins. There were two basic kinds of moccasins: hard-soled and soft-soled. Though a few tribes wove them from corn husks and basswood fibers, almost all moccasins were made from soft, tanned skins and many were decorated with beads and porcupine quills. Plains Indians, such as the Sioux, often made hard-soled moccasins to protect them from the sharp grass and hidden objects of the prairies. Woodlands tribes most often used a soft sole. Figures: (1) a pair of Winnebago women's moccasins with a large flap folded down over the toe; (2, 3) two types of Woodlands soft-soled moccasins; (4) Navajo hard-soled moccasins; (5) a Woodlands two-piece stocking moccasin; (6) a modern Winnebago shoe (left) and a Woodlands soft-soled one-piece moccasin; (7) a western Plains moccasin.

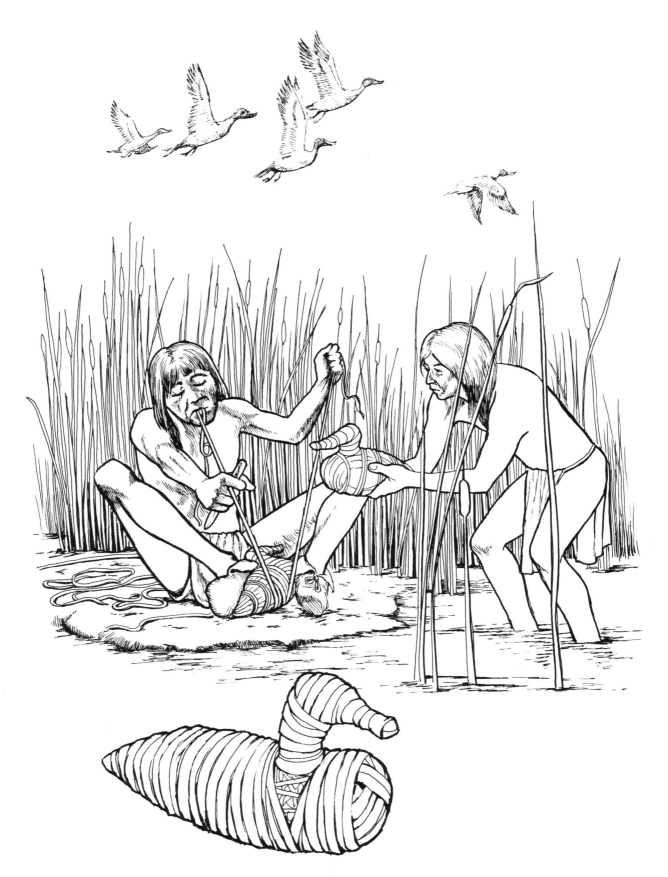

Making decoys. Duck decoys were designed to lure wild ducks closer to the shore. When the ducks came close enough, the hunters, who were hiding in the brush, would fling nets made of twined willow strips over them. The decoys were made of cattail leaves, yucca strips and feathers, and bound together with thongs and reeds. They were then painted to resemble the wild birds.

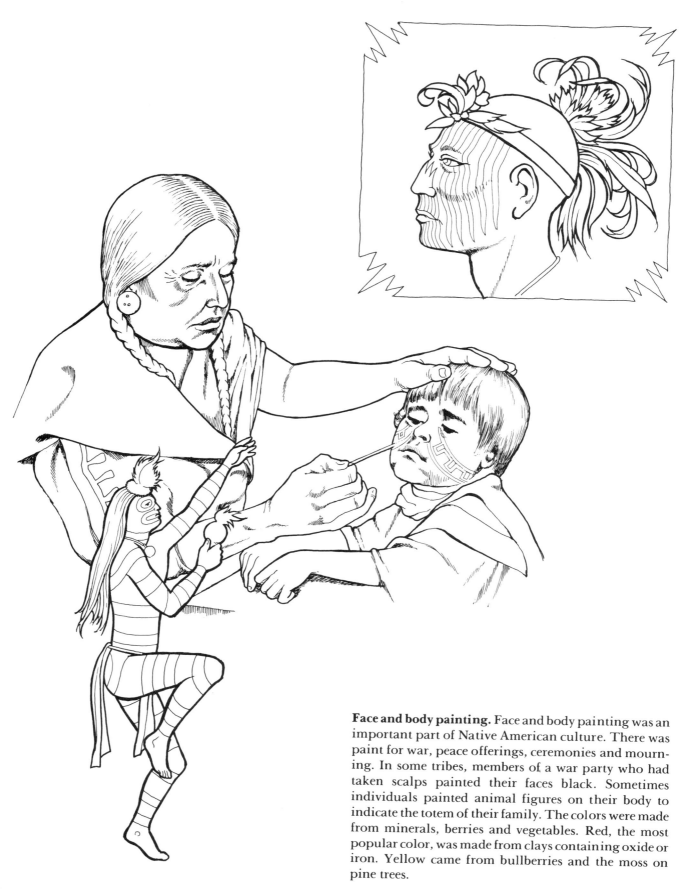

Face and body painting. Face and body painting was an important part of Native American culture. There was paint for war, peace offerings, ceremonies and mourning. In some tribes, members of a war party who had taken scalps painted their faces black. Sometimes individuals painted animal figures on their body to indicate the totem of their family. The colors were made from minerals, berries and vegetables. Red, the most popular color, was made from clays containing oxide or iron. Yellow came from bullberries and the moss on pine trees.

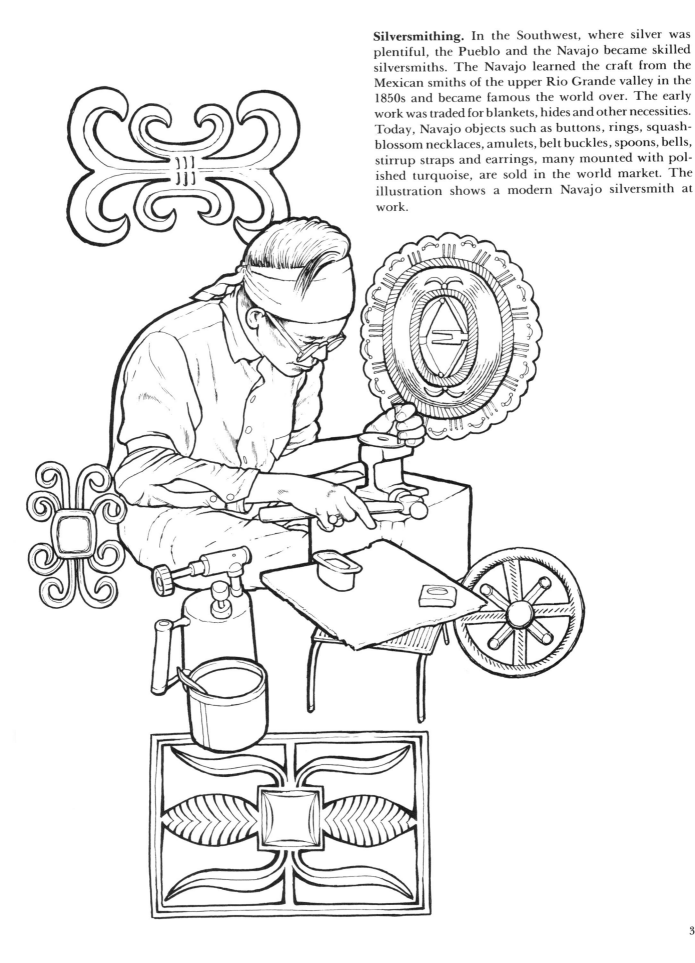

Silversmithing. In the Southwest, where silver was plentiful, the Pueblo and the Navajo became skilled silversmiths. The Navajo learned the craft from the Mexican smiths of the upper Rio Grande valley in the 1850s and became famous the world over. The early work was traded for blankets, hides and other necessities. Today, Navajo objects such as buttons, rings, squash-blossom necklaces, amulets, belt buckles, spoons, bells, stirrup straps and earrings, many mounted with polished turquoise, are sold in the world market. The illustration shows a modern Navajo silversmith at work.

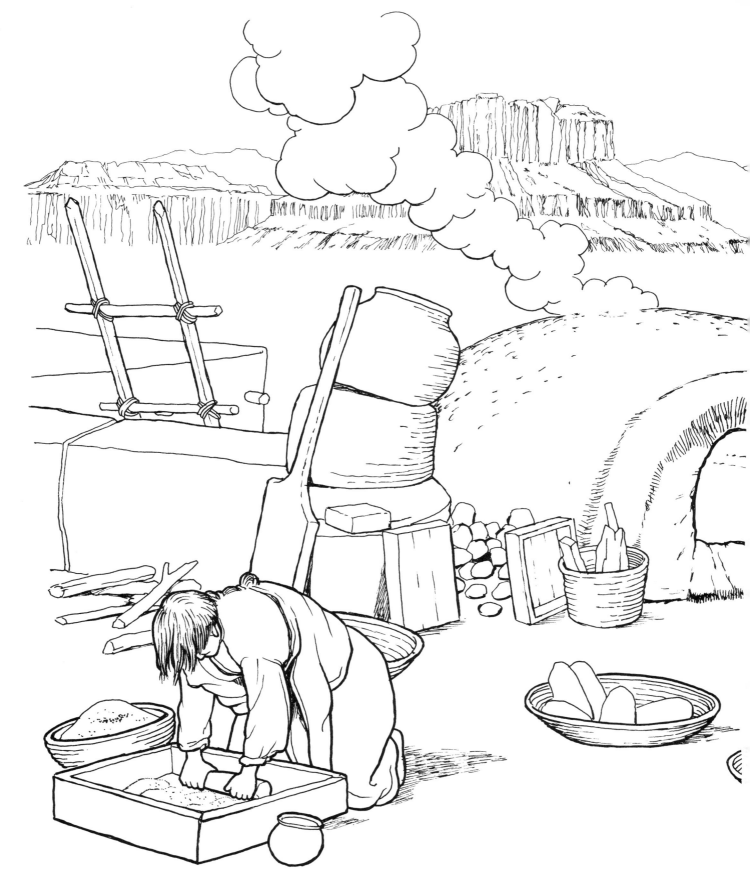

Baking bread. The bread oven operated by the Pueblo woman in the illustration is located on the roof of the dwelling, three stories above the ground. The Pueblo often built their villages on the top of a high, flat mountain, or mesa, hundreds of feet above the plain to protect themselves from the raids of roving Apache tribes. In addition to protection, they had a beautiful view of the surrounding area. This woman, however, is

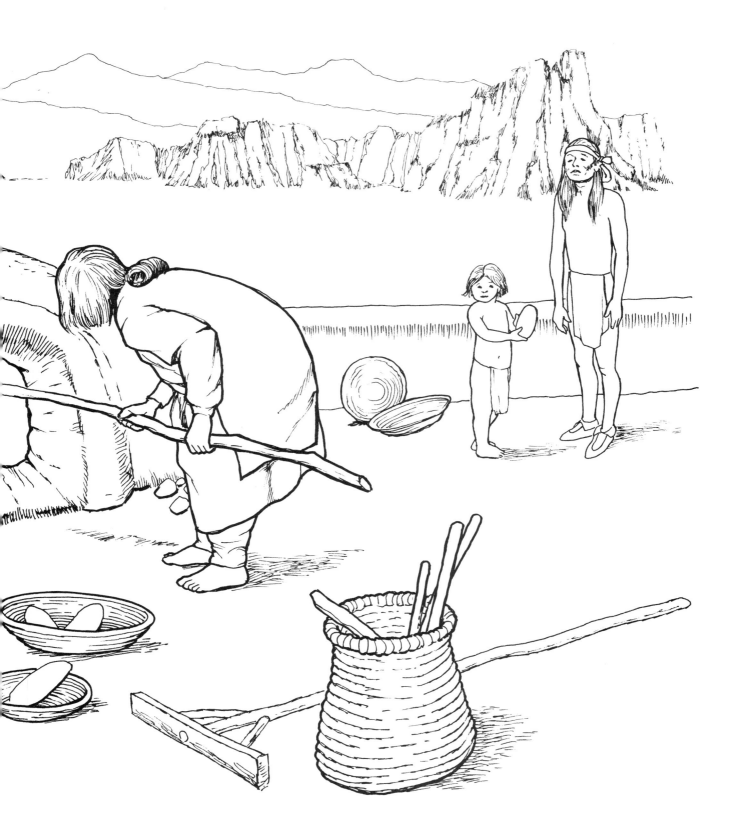

too busy making bread to enjoy the scenery. To make the oven work, she had to build a fire and stoke it until it was as hot as possible. She then had to scrape the fire out of the oven and put the bread dough on the hot rocks of the oven floor. At the left, a woman is grinding parched corn into flour.

Making baskets. One of the most ancient and utilitarian Native American arts is basketmaking. Baskets were used in every facet of domestic, religious and social life. A skill practiced almost exclusively by women, basketmaking has been around since the beginning of Indian civilization and was practiced by all the Indian tribes. Above, we see a Hopi weaver at work and an aged man bearing a rough and sturdy basket filled with firewood. The examples of basketry are from the Southwest and the Northwest Coast.

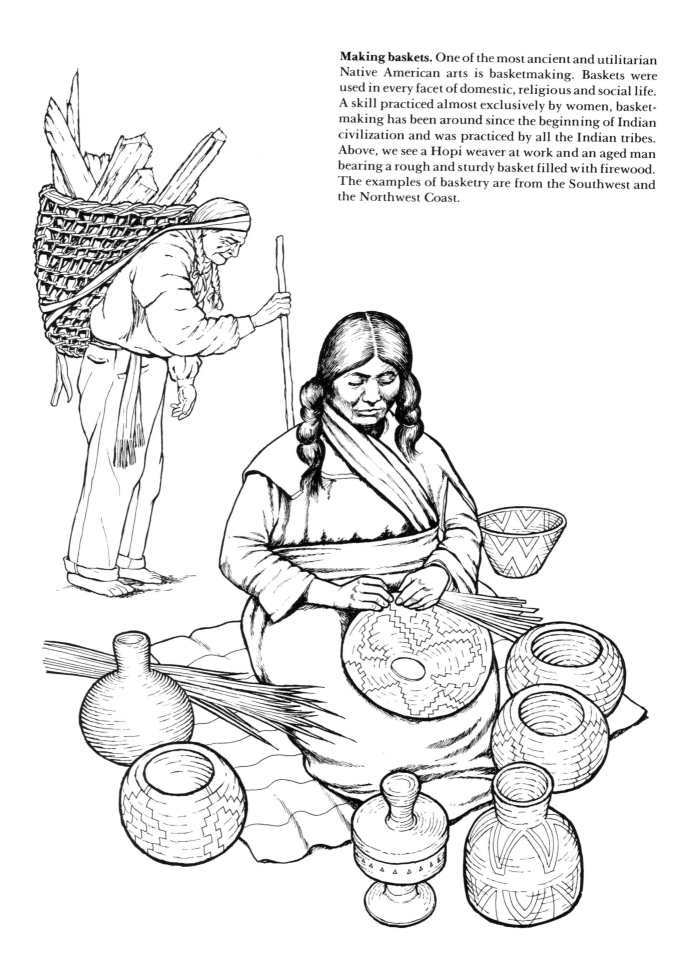

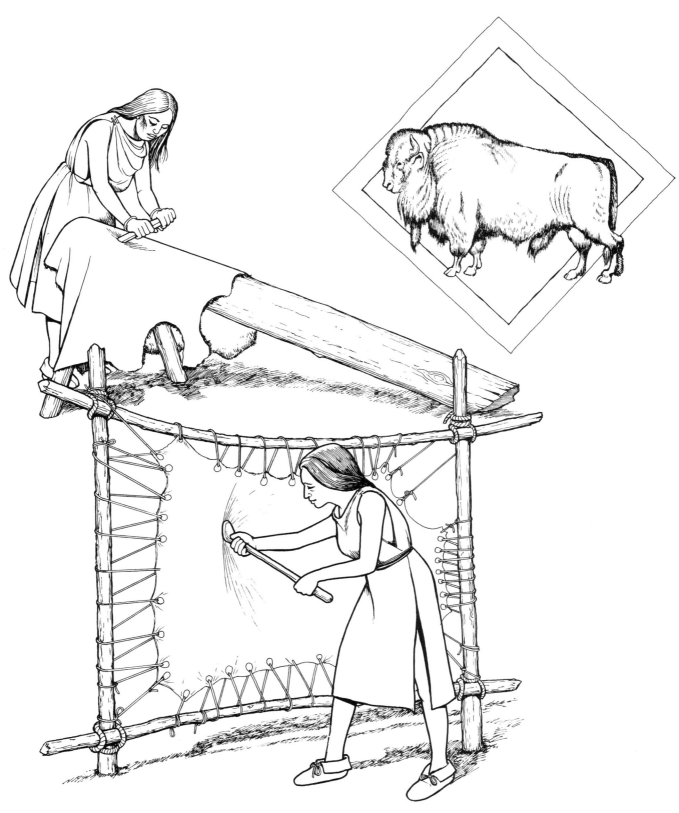

Preparing hides. Women did most of the domestic work in Indian society, including tending to the children, preparing food, raising teepees, farming, making baskets and pottery, and other important chores. Above we see women preparing buffalo hides to be used in making clothes, robes and lodge covers. At the top, a woman fleshes a hide, removing the soft tissue and hair with a fleshing tool made of buffalo bone. After fleshing, the hide is softened and smoothed with an adz-like tool. If it is to be made into clothing, the hide is further softened with a mixture of buffalo brain and fat. At the bottom, the hide is being stretched on a frame and smoothed one last time before being cut into shape.

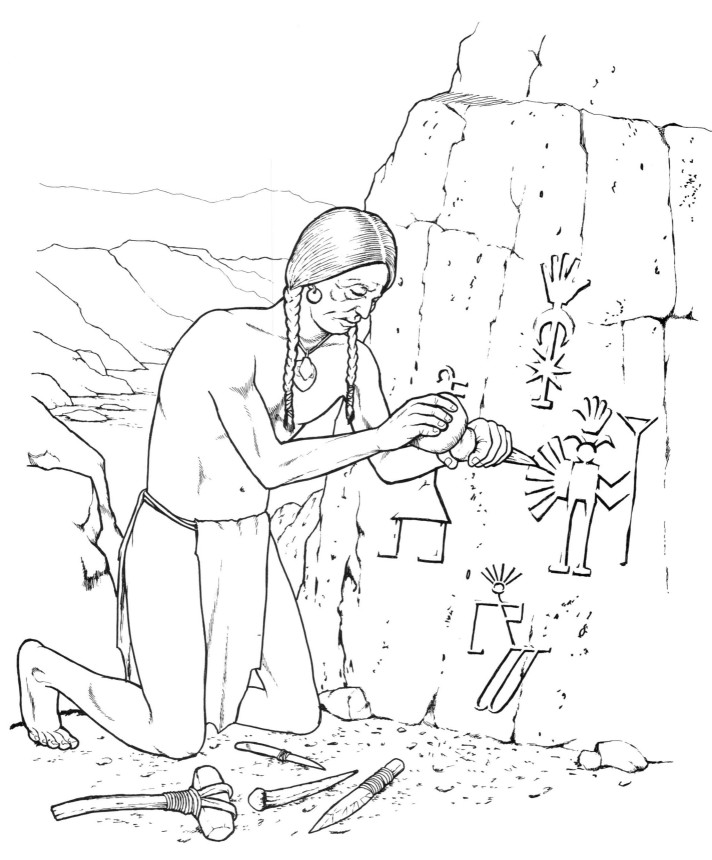

Carving in rock. This illustration shows a man carving designs (petroglyphs) into a rock wall high in the Western mountains. Like the designs painted on teepees, rock carvings on walls and buildings had a very specific meaning to the creator of the design. The craftsmen used tools made of hard stones, bones and antler points, and colored their designs with paint made from tree bark, rocks, earth, animals and plants. Common objects in the designs included animals, birds, trees, people and geometric symbols.

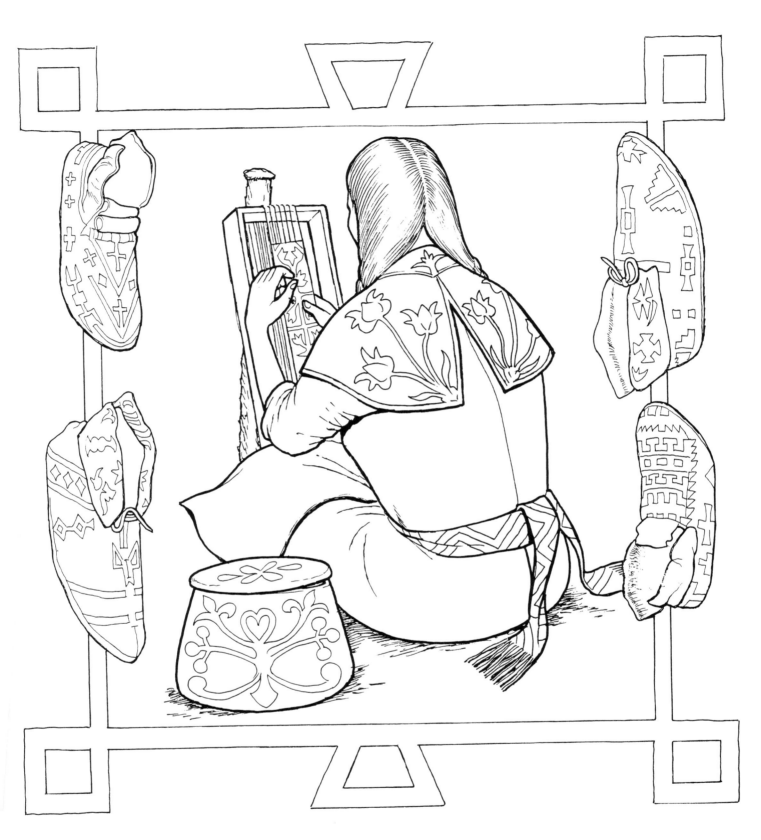

Beadwork. Native Americans began using Italian beads after the arrival of the Europeans. They began to acquire the beads as early as 1616 by trading furs and other items. The beads replaced porcupine quills, which were dyed and used to trim clothes and moccasins.

In the drawing, an Ojibwa woman weaves a beaded belt on a small frame loom. The loom leans on a stake in the ground, and the strings are wound around the frame at consistent intervals. The beaded moccasins at the sides are Arapaho.

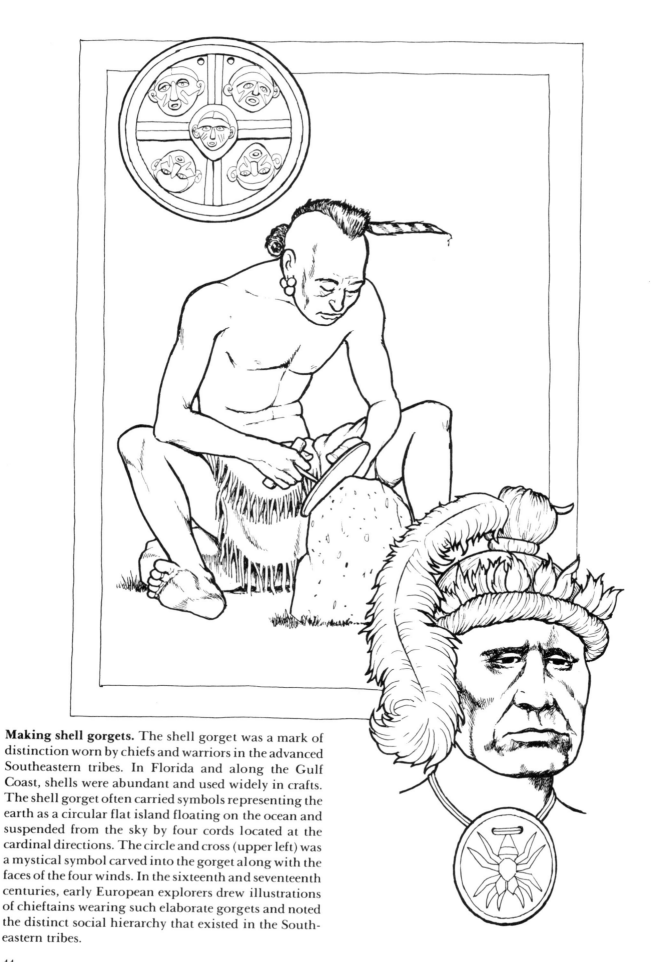

Making shell gorgets. The shell gorget was a mark of distinction worn by chiefs and warriors in the advanced Southeastern tribes. In Florida and along the Gulf Coast, shells were abundant and used widely in crafts. The shell gorget often carried symbols representing the earth as a circular flat island floating on the ocean and suspended from the sky by four cords located at the cardinal directions. The circle and cross (upper left) was a mystical symbol carved into the gorget along with the faces of the four winds. In the sixteenth and seventeenth centuries, early European explorers drew illustrations of chieftains wearing such elaborate gorgets and noted the distinct social hierarchy that existed in the Southeastern tribes.

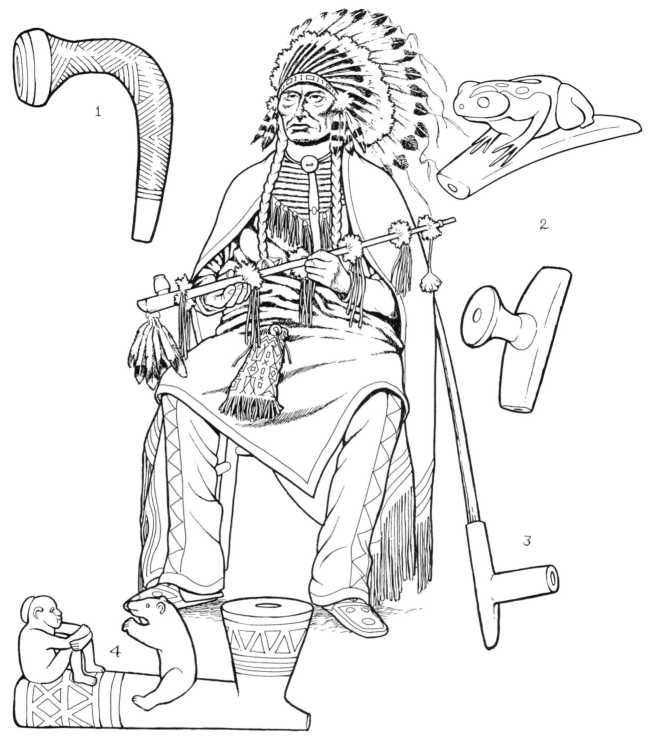

Making tobacco pipes. Smoking tobacco was a social and ceremonial event performed to bring good luck and to make peace among warring tribes. Medicine pipes, which were considered sacred items, were passed in ceremonies to cure the sick and to bring success in battle. When not in use, they were wrapped in bundles, covered with furs and hung in a special place. The most famous pipe is the peace pipe, which could be up to 40 inches long and was sometimes carved in the likeness of a bird or snake. Often, pipes were decorated with feathers or tufts of brightly dyed horsehair. The smoking of the pipe was ritualistic. The Medicine Man would light the pipe, blow a puff of smoke toward the sky and point the pipe stem upward as a prayer. He then pointed the stem toward the earth and the four winds. The illustration shows a Blackfoot chief holding a medicine pipe. Around him are: (1) an Iroquois platform stone pipe bowl, (2) two types of pipe bowls made by the ancient mound builders of the Mississippi valley, (3) a western Plains Indian pipe, (4) a carved Pawnee pipe bowl.

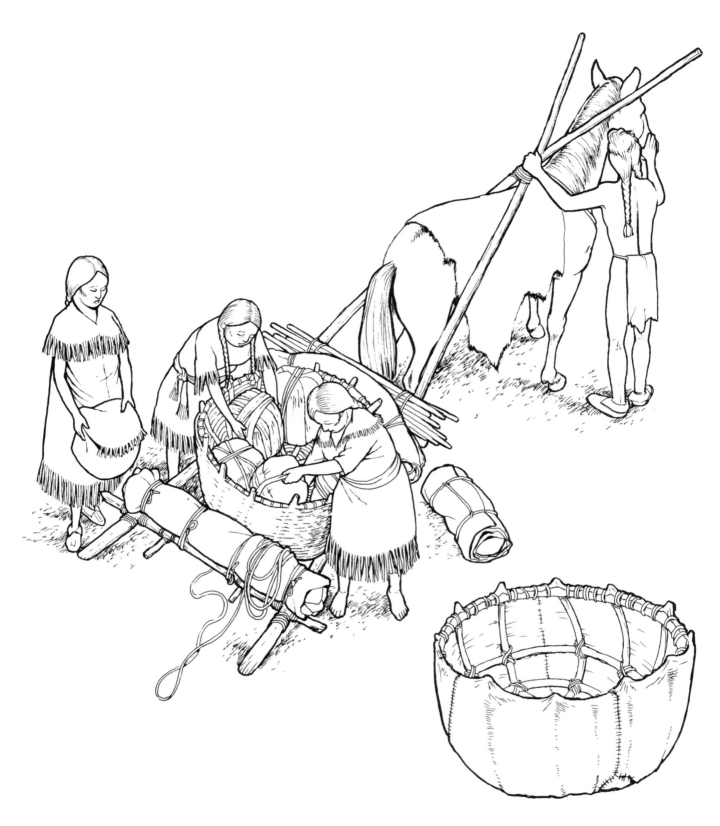

Plains Indians preparing a travois and bull boat. The travois, originally smaller and designed to be pulled by dogs, was used to carry clothes, teepee coverings and belongings when tribes had to move. The smaller version was used until the Europeans brought horses to the New World. The bull boat was a bowl-shaped vessel of green buffalo hides stretched over a framework of willow saplings. It aided in the transportation of large loads across rivers and lakes. When blocked by a waterway, the women would ferry people and equipment across by paddling the bull boat while the men swam the horses to the other side. Once across, the bull boat was reloaded onto the travois and filled with gear.

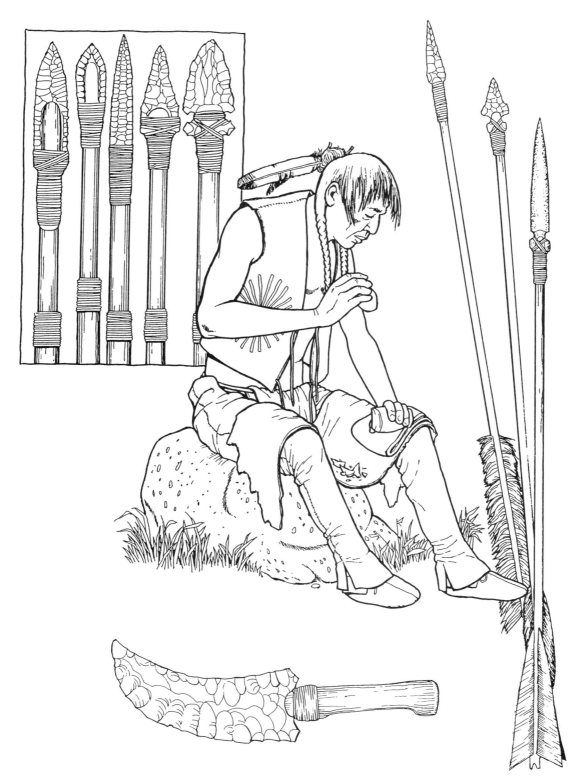

Making tools and weapons from flint. The craftsman in this picture is practicing an ancient art: chipping a flake from a bit of flint in order to make a spearhead. The flake is sharpened and attached to the shaft with leather. Before 1000 B.C., when the bow and arrow became paramount, the primary weapon of all North American Indians was the spear. Spearheads have been discovered that are around 12,000 years old. The illustrations show the evolution of the spear as a hunting weapon. Early spears were used to stab the prey several times. Later points were equipped with barbs designed to lodge the spear securely in the prey while the hunter pursued the wounded animal. The arrows are capped with different types of heads, the last one on the right being made of stone rather than flint. The stone knife at the bottom is a ceremonial instrument made of obsidian, a volcanic rock. The handle is of wood.

DOVER COLORING BOOKS

LITTLE MERMAID COLORING BOOK, Thea Kliros and Hans Christian Andersen. (27130-7) $2.95

EXPLORATION OF NORTH AMERICA COLORING BOOK, Peter F. Copeland. (27123-4) $2.95

WILD ANIMALS STAINED GLASS COLORING BOOK, John Green. (26982-5) $3.95

HISTORIC HOUSES OF NEW ENGLAND COLORING BOOK, A. G. Smith. (27167-6) $2.95

FRENCH ALPHABET COLORING BOOK, Nina Barbaresi. (27247-8) $2.50

SPANISH ALPHABET COLORING BOOK, Nina Barbaresi. (27249-4) $2.50

SHIPWRECKS AND SUNKEN TREASURES COLORING BOOK, Peter F. Copeland. (27286-9) $2.95

SLEEPING BEAUTY COLORING BOOK, Grimm Bros. & Thea Kliros. (27318-0) $2.95

ALPHABET HIDDEN PICTURE COLORING BOOK, Anna Pomaska. (27261-3) $2.50

CALIFORNIA MISSIONS COLORING BOOK, David Rickman. (27346-6) $2.95

BUTTERFLIES COLORING BOOK, Jan Sovak. (27335-0) $2.95

INDIAN TRIBES OF NORTH AMERICA COLORING BOOK, Peter F. Copeland. (26303-7) $2.95

BIRDS OF PREY COLORING BOOK, John Green. (25989-7) $2.95

LIFE IN ANCIENT EGYPT COLORING BOOK, John Green and Stanley Appelbaum. (26130-1) $2.95

WHALES AND DOLPHINS COLORING BOOK, John Green. (26306-1) $2.95

DINOSAUR ABC COLORING BOOK, Llyn Hunter. (25786-X) $2.50

SHARKS OF THE WORLD COLORING BOOK, Llyn Hunter. (26137-9) $2.95

FUN WITH OPPOSITES COLORING BOOK, Anna Pomaska and Suzanne Ross. (25983-8) $2.50

DINOSAUR LIFE ACTIVITY BOOK, Donald Silver and Patricia Wynne. (25809-2) $2.50

THE VELVETEEN RABBIT COLORING BOOK, Margery Williams and Thea Kliros. (Available in United States only). (25924-2) $2.95

COLUMBUS DISCOVERS AMERICA COLORING BOOK, Peter F. Copeland. (25542-5) $2.95

STORY OF THE AMERICAN REVOLUTION COLORING BOOK, Peter Copeland. (25648-0) $2.95

HORSES OF THE WORLD COLORING BOOK, John Green. (24985-9) $2.95

WILD ANIMALS COLORING BOOK, John Green. (25476-3) $2.95

Paperbound unless otherwise indicated. Prices subject to change without notice. Available at your book dealer or write for free catalogues to Dept. 23, Dover Publications, Inc., 31 East 2nd Street, Mineola, N.Y. 11501. Please indicate field of interest. Each year Dover publishes over 200 books on fine art, music, crafts and needlework, antiques, languages, literature, children's books, chess, cookery, nature, anthropology, science, mathematics, and other areas.

Manufactured in the U.S.A.